A ROCKY MOUNTAIN SKETCHBOOK

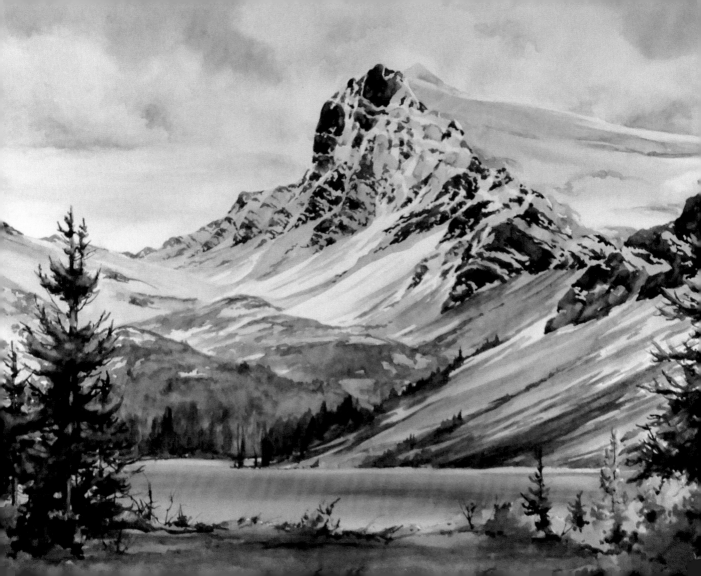

A Rocky Mountain Sketchbook

A Step-by-Step Guide to Watercolour Painting
and Drawing in the Mountain Landscape

VOLUME 1

DONNA JO MASSIE

RMB

RMB | Rocky Mountain Books Ltd.
rmbooks.com
@rmbooks
facebook.com/rmbooks

Cataloguing data available from Library and Archives Canada
ISBN 9781771601566 (hardcover)

Frontispiece: *Bow Lake*

The author and publishers of this book gratefully acknowledge the generous support of the estate of Nell Whellams in the completion of this project. Ms. Whellams was a longtime member of the Alpine Club of Canada and a committed mountaineer. We hope this celebration of the beauty of high places captures her own love for the mountain world.

Printed and bound in Canada by Friesens

Distributed in Canada by Heritage Group Distribution and in the U.S. by Publishers Group West

For information on purchasing bulk quantities of this book, or to obtain media excerpts or invite the author to speak at an event, please visit rmbooks.com and select the "Contact Us" tab.

RMB | Rocky Mountain Books is dedicated to the environment and committed to reducing the destruction of old-growth forests. Our books are produced with respect for the future and consideration for the past.

We acknowledge the financial support of the Government of Canada through the Canada Book Fund and the Canada Council for the Arts, and of the province of British Columbia through the British Columbia Arts Council and the Book Publishing Tax Credit.

This book is dedicated to the memory of
James E. Massie,
Ottis Massie and Cora Cathey,
and to my son Clay —
my greatest creation.

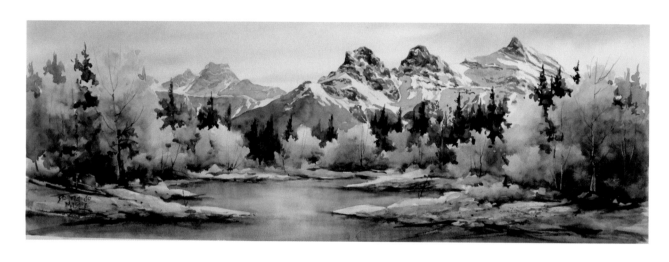

The Three Sisters

Contents

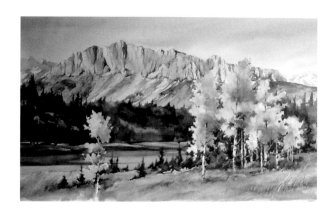

Yamnuska

Acknowledgements

This book would not have been possible without the encouragement and assistance of Bob Sandford — he has supported mountain art and artists with an unswerving dedication — or without the technical and design help given by Geoff Powter.

Betty Mahood and Barbara West have provided countless hours of "sideline coaching," long walks and friendship that knows no bounds.

I am constantly inspired by the enthusiasm and dedication of my friends who are also teachers: Heather Woodwark, Jo Pilar, Kathryn Walton, Sue Bjorge, Carol Kroll and Susan Scowcroft. To Vladimir for Arnica, Boom, Smith, Vista and art — my thanks.

Thank you to my Canadian family for over 22 years — Terry Naffin, Ruth Kleinitz, Donna Ryan, Patricia Heal and Bev Trim — and my Smoky Mountain family — Patrick Choate, Dot and D.C. Franklin — for understanding the peace and beauty of these Rockies.

Many thanks to John Fisher, Linda Marsden, David Robinson, Barbara West, Kathryn Walton and Joseph Potts for "testing" pages, listening to my ideas and sharing their thoughts about art and this book.

This project would have taken longer if not for the laughter and art excursions with Susan Gottselig and Heather Mortimer.

Many thanks to Joel Christensen and Ron Chamney at Kananaskis Country.

Finally, I owe a debt of gratitude to all my students for making teaching so rewarding. Wednesday Afternoon, my longest-running class, where we have laughed as much as we have painted; the Thursday Morning "Wild Bunch" for their enthusiasm and love of art; and the Banff folks — Clara Tarchuk, Catharine Hardie-Wigram, Jean Jantzen, Kay Watt, Mary Costigan and Velma Ryan — for driving to Canmore year after year. For their friendship from the first class ten years ago — and they are still painting with me — Norman Witham, Agnes Le Blanc and Eileen Ashdown. With fond memories of my dear friend and student Una Grassick. My students have given me the confidence and courage to believe that I should share my thoughts on teaching and my love of watercolours and these magnificent Rocky Mountains.

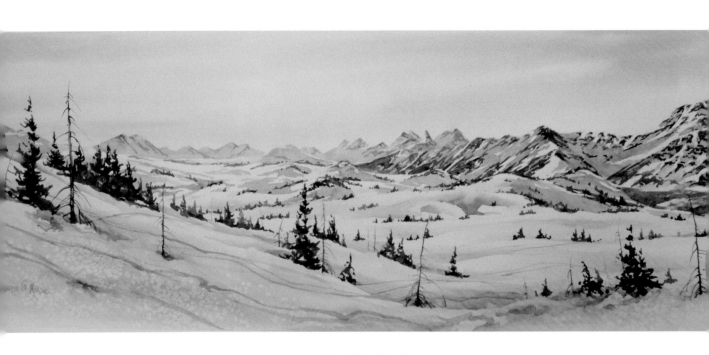

Sunshine Meadows

Introduction

During the past ten years, I have taught workshops for many diverse groups and corporations — the Calgary Zoo, the Alpine Club of Canada, the Whyte Museum, and Alberta Foundation for the Arts — as well as ongoing adult classes in Canmore. I have worked with ages six to 86, and I have learned as much as I have taught. I would like to share some of the things I have learned about art, people and this thing called "creativity."

In this book, the basics of watercolour painting and sketching are explained in a series of step-by-step demonstrations, and the supplies are listed for a beginning watercolour painter. You will also gain an appreciation for this medium as you see how a painting/sketch is "made." However, in order to learn anything, there is something absolutely essential: you must relax and have fun!

I am convinced that art is teachable and learnable.

There is no "art gene" that some people have and others missed.

It has always amazed me that people seem to think they should enter a workshop, sit down and automatically create a finished product. Yet, these same people wouldn't expect to sit down at a piano and play with no instructions! So it is with painting — you have to learn the basic skills and then practise, practise, practise.

More recently, I have formed the opinion that creativity is an essential human need. One of the first things humans did — besides making stone tools, hunting and gathering — was to dip their hands in earthen pigments and make images on cave walls. Art is, quite simply, the domain of all people.

After you read through a section, venture out into the mountains or simply look out your window and create your own unique watercolour sketch.

My passion is painting. I'm happiest with a paintbrush in my hand. May you catch some of the "creative" spirit and passion as you create your own sketches!

What to Take on a Sketching Trip

If you are hiking in the mountains, you need to pack small and keep sketching and painting materials to a minimum. Remember, you also have to pack for the sudden weather changes that can occur at any time of year in the mountains — that means taking a jacket, rain gear and lunch. Here are the items that I put in a plastic bag and tuck in my pack.

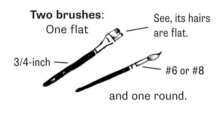

Two brushes:
One flat

See, its hairs are flat.

3/4-inch

#6 or #8

and one round.

To keep your brushes in good shape you can make a **brush holder** from a cardboard tube used for wrapping paper. Make a top and bottom out of cardboard.

Palette: Fill with basic colours.* There are metal folding art palettes, 8 x 6 inches, or take a child's watercolour box and fill the empty colour compartments with your colours!

*Start with a few colours and get to know them well. I suggest three primary colours, one green, and two additional earth colours: French Ultramarine, New Gamboge, Alizarin Crimson, Winsor/Phthalo Green, Raw Sienna and Burnt Sienna are good. (Winsor Blue-Red, Burnt Umber and Vermilion are also good mountain colours.)

Watercolour paper:*
140 lb. cold press

or

Watercolour block:
a pad of watercolour
papers, glued at
sides, ready to use.

*Cut into sizes about
10 x 12 inches or
8 x 6 inches.

Simply slip a knife under the
edge, cut the top sheet off and
you are ready to paint again.
Or hole-punch watercolour
paper and make your own sketch-
book using a three-ring binder.

Black **Plexiglas** or
sturdy cardboard 1/2
inch larger than
watercolour paper.

Ready-to-take-out
sheets of paper
for hiking.

Later, place in **three-ring binder**.

Mechanical pencil: Can be placed in brush holder — never needs sharpening! A **drawing pen** can be used for writing in the journal, or for adding details or edges to a picture.

Plastic eraser, white, found in office-supply stores — it won't tear or smudge watercolour paper.

Masking tape to create edges for painting

Place everything in a **plastic bag**. Not only does it keep everything dry in case of rain or snow, but you can pull out the one bag and be ready to sketch and paint ...

Film containers hold enough water to do a small sketch.

Tissue paper: Always handy when hiking. Can be used to clean brushes and for dabbing in order to control water on brush.

How to Begin a Sketchbook

Use the masking tape to create a "frame" on the watercolour paper.

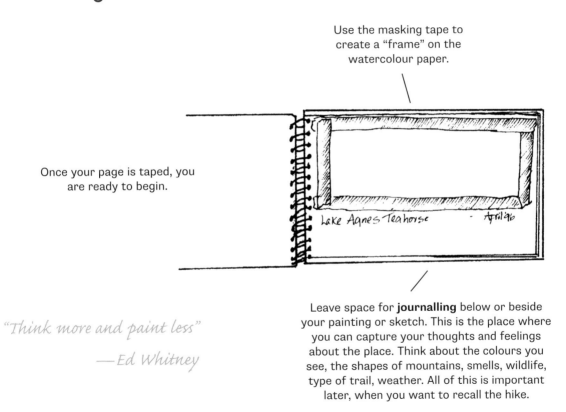

Lake Agnes Teahouse - April 96

Once your page is taped, you are ready to begin.

"Think more and paint less"

—Ed Whitney

Leave space for **journalling** below or beside your painting or sketch. This is the place where you can capture your thoughts and feelings about the place. Think about the colours you see, the shapes of mountains, smells, wildlife, type of trail, weather. All of this is important later, when you want to recall the hike.

The First Thing: Framing the View

Everywhere you look, there are spectacular views, but each person has a favourite mountain or lake — or even a rock where they like to have lunch. You have a portable viewfinder! Use your hands, as artists have done for years, to frame a view that *you* like.

"Painting is just another way of keeping a diary."

— Pablo Picasso

PENCILS, YOUR STARTING TOOLS

An H pencil is good for sketching. H pencils have hard leads; 9H is the hardest, which means it has a fine, light line. B pencils are soft and smudge easily. A mechanical pencil with H lead is ideal for your hiking pack — no pencil sharpener necessary!

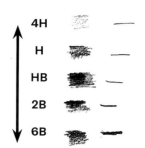

4H

H

HB

2B

6B

Blocking the View

Let's answer one of the most common questions and start drawing:

WHERE DO I START WITH A SKETCH/DRAWING?

First, determine the size of your paper and decide whether your view works better horizontally or vertically.

Then, find the big shapes in your view: squares, circles, rectangles and triangles are the big shapes.

Very lightly do a "shadow outline"* of these shapes on your paper.

Vertical: Good for height.

Horizontal: Good for a wide feeling.

Rectangular: Vary the shape either way you want – it's **your** picture after all!

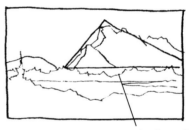

Mount Rundle, the landmark of Banff, is simply a triangle.

*Hint: You should hold your pencil in the middle of its length to make this a light sketch.

X marks the spot.

"Art is the only way to run away without leaving home" — *Twyla Tharp*

On the Edge

Once you have the outline on your paper, you are ready to actually draw what you see. Let's take the fear out of drawing by looking at a few basics for putting pencil to paper. Remember, the more you do the better you become. And be kind to yourself; don't expect perfection the first try — you are learning.

Always draw the longest line first. This is usually the shoreline, horizon (hard to see in the mountains), or bottom of the distant trees. You can hang everything else on this line; it gives you a base.

Next, you want to draw the closest line that touches the base line. In the Mount Rundle picture, this is the small mountain on the left — Tunnel Mountain.

Look: What you are drawing should be the edge (no details) — the line where the mountain touches the sky. As you move along this line, stop your pencil, look up at the mountain edge and see the mountain as a series of diagonal lines, curves and straight lines.

"Into each life some rain must fall"

— Henry Wadsworth Longfellow

FIVE LINES MAKE THE MOUNTAIN

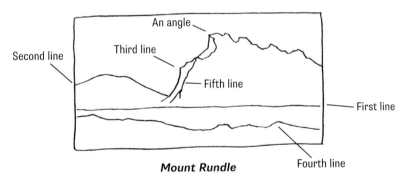

Mount Rundle

Remember: you are sketching, so hold your pencil
at the halfway mark, but your line can be firmer
and darker than the shadow outline on the paper.

Details, Details

Details in the landscape can be added next, including trees, branches, rocks and grass. Each one has a shape, or symbol line that lets us know what it is:

Don't get carried away at this point, just sketch in the big shapes — you can't see twigs from two miles away!

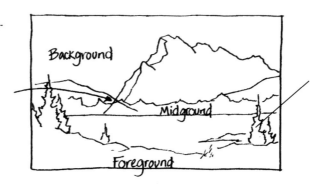

Background

Midground

Foreground

Erase overlapping lines so you only see the outline of the object in front.

TIPI TREES

Trees in the Rocky Mountains are primarily coniferous: pine, spruce, fir. Larch trees are the only coniferous trees that lose their needles. The basic shape of these trees is triangular with branches getting closer together and longer at the bottom. However, larches can look as if their upper branches are arms waving in all directions. The trick to drawing and painting trees is to make a light pencil "tipi" and fit your tree into it.

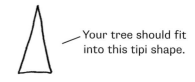

Your tree should fit into this tipi shape.

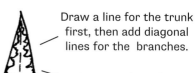

Draw a line for the trunk first, then add diagonal lines for the branches.

Vary your branches side to side!

More on Trees

Aspen poplar, Rocky Mountain Douglas fir, lodgepole pine, balsam poplar, limber pine

Trees in the *distance* (midground) should only be shown as shapes — their outline is all that is necessary. It's part of the *perspective*: things in the distance are bluer and have less detail.

Foreground trees: Practise before adding a few close trees to your picture. The **Three Bears rule*** applies to all nature details.

*There should always be a Mama Tree, a Daddy Tree and a Baby Tree.

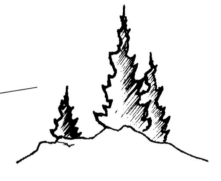

The Three Bears rule

Remembering the Three Bears rule will help you vary the height and number of trees. The result is more interesting than if all the trees are uniform and creates a landscape picture that is like nature: there are no evenly spaced tree forms in nature! This rule also applies to rocks, clouds, people — everything.

"Art is a metaphor – it's like it, but it's not!"

—Ed Whitney

Tree Rules

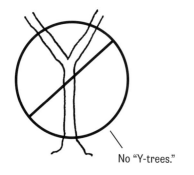

No "Y-trees."

1. Leave holes for the birds to fly through. No solid "blob trees."
2. Branches and trunks must get smaller in size as they grow up and out from the roots.
3. No "Y-trees." There is only one main trunk.
4. Look — really look — at trees: the place where the trunk grows out of the ground, the shape and angle of the branches, their colours, everything! You will discover many things you never saw before.

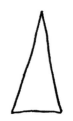

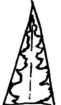

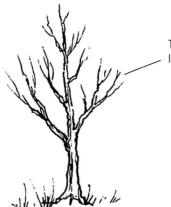

Trees look like this...

...and like this!

22

...and More Tree Rules

Two deciduous trees found in the Rocky Mountains are balsam poplar and aspen poplar. The basic "big shape" of these trees is circular with almost straight trunks. But be careful that your finished trees don't look like a stand of lollipops!

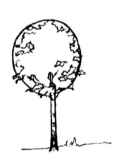

You can see branches through some of the foliage. Again, make sure you leave holes for the birds to fly through!

These "holes" are negative spaces — shapes that we think of as empty spaces or nothingness. Teaching yourself to see these spaces as shapes will help you draw everything better!

PERSPECTIVE AND TREES

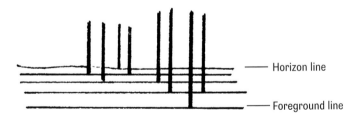

— Horizon line

— Foreground line

As you get closer to the horizon, the line of trees gets closer together and the height becomes shorter — look for yourself!

"Art is like a border of flowers along the course of civilization."
— Lincoln Steffens

Now for the Fun! Adding Water and Colour

Getting to know your colours and values (lights and darks)

Open your palette and use your round brush to wet
the top of each blob of paint. Carry some paint to
your mixing section with your brush.

The trick to making a darker colour is to
take all the water out of the brush so you
only pick up paint; if your brush has water
loaded in the belly, the colour will be diluted.

WATER → sponge

Take extra water out
of the brush.

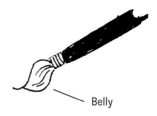

Belly

Add *water* to make a lighter colour.

Add more *paint* to make a darker colour.

Use a scrap piece of watercolour paper and try to get different values of the colours on your palette.

Next! Mix it up. On the same paper (use the back), mix some of your primary colours to create new (secondary) colours. Clean your brush by shaking it around in your water container after each colour has been mixed. This will keep your colours clean.

About Colours or, When Blue Isn't Blue

Some of the frustration of painting with watercolours arises when your painting becomes "muddy" and has no lively colour. But don't quit. Here are a few tips about paint personalities. (For example, I like to call Alizarin Crimson the Howard Stern of watercolours because it is so strong you can only take a little bit at a time!)

You can make a brilliant purple by mixing primary colours that only have reds and blues. The same applies to mixtures of orange and green; mix primary colours with only yellows and reds, and primary colours with blues and yellows.

To create vivid colours, mix the primary colours that share a side of the triangle: for example, French Ultramarine and Alizarin Crimson.

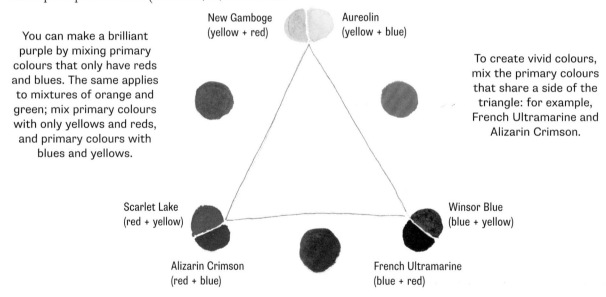

New Gamboge (yellow + red)

Aureolin (yellow + blue)

Scarlet Lake (red + yellow)

Winsor Blue (blue + yellow)

Alizarin Crimson (red + blue)

French Ultramarine (blue + red)

The Colour Triangle, with **primary colours** at the corners and **secondary** colour blends along the sides.

A Brush with Fun

How to use the round brush in fun new ways

The round brush can be handled in several different ways to create a variety of shapes. Let's learn how to handle this brush by practising on flower shapes.

FLOWER #1

Choose a colour — red, yellow or blue — and make a circle of colour on the watercolour paper for the centre of your flower. Let this dry.

Next, choose another colour and mix it with water to create a puddle of rich colour.

Lay your brush *sideways* in the puddle of colour so it can load the belly with colour. You want to have a lot of colour on your brush so the paint will almost *jump off* the brush when you touch the paper!

Take the brush to your watercolour paper. Push the brush down to the metal ferrule, tip pointing towards the flower centre, then slowly *pull* the brush away from the centre. As you pull the brush, point the top of the brush straight up to the ceiling and *lift slowly up and off* the paper.

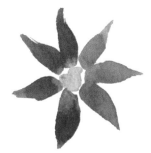

Move around in a circle to create a flower. Depending on the flower, you may want to have a large or small centre. Overlap some of the petals for a realistic flower.

#6 or #8 round brush: This brush should have "snap." When it is wet and you push it down on the paper, it should snap back into shape when lifted, not stay in this shape.

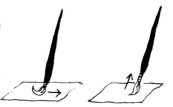

Flower brush stroke

• Push the brush down.

• Pull across paper, slowly, so the paint can flow off the brush.

• Lift straight up when you have a petal shape the size you want.

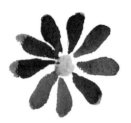

FLOWER #2

Reverse what you just did to create a different flower petal; start at the outside of the flower petal, move to the centre and pull up slowly. Wasn't that fun and easy?

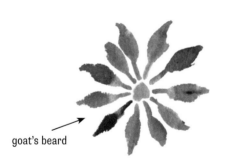

goat's beard

FLOWER #3

Now, let's use the brush tip only. Starting at the centre, make a circle of colour. Then, make the petals by using only the tip to create a thin line. Continuing, push the brush down halfway to the metal ferrule and slowly pull across the paper and lift up. This brush stroke should give you a petal that looks like a goat's beard.

Start with a thin line, then push brush down and pull away from the centre.

FLOWER #4

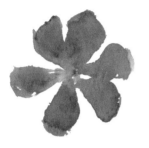

To make a flower shape with big petals — for example, a wild rose, cinquefoil or violet — fill your brush with colour, then push the ferrule and slowly twist the handle between your fingers so that the hairs of the brush make a fan shape and the paint flows off the brush. Place your brush filled with paint next to the first petal and repeat the shape. Leave room for a centre as you move around the flower shape. If you add the centre while the petals are still wet, the centre colour will bleed into the petals, giving a realistic glow.

Push brush down and gently twist.

FLOWER #5

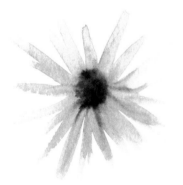

Let's create a flower shape for a brown-eyed Susan or a golden fleabane. Place a small dot of yellow paint for a centre. Load your brush with yellow paint and, starting at the centre, push your brush *halfway* down to the ferrule, then pull *out* slowly, lifting when the petal is long enough. Fill brush with paint every two strokes. Add brown to the centre for a brown-eyed Susan. Add more brown when the centre is dry and pull some of the colour into the petals.

Pull brush out from the centre, then lift.

Try your hand at some of these unique mountain flower shapes.

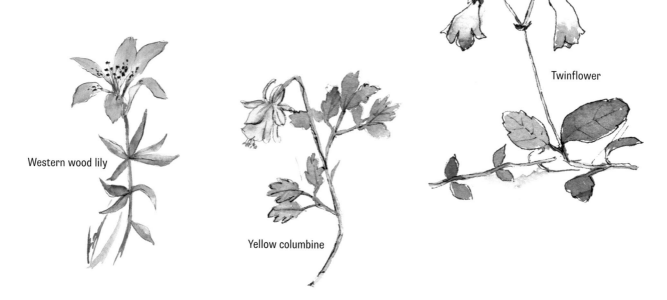

Western wood lily

Yellow columbine

Twinflower

NOW MAKE STEMS AND LEAVES

First, mix two or three puddles of green. French Ultramarine and New Gamboge, *or* Winsor Green-Blue (or Hooker's Green) with a bit of Alizarin Crimson. Then, on the edge of these puddles, add New Gamboge to make a light green, or Burnt Sienna to make yet another shade of green.

Load your round (#8) brush and do "botanical" stems and leaves by painting directly on the paper. Hold the brush so that *the top points up to the ceiling*, then touch the tip of the brush on the paper and slowly pull it away from you to create a small, fine line. Relax and let the paint flow off the brush. If you want a thicker line, push the tip of the brush further down onto the paper.

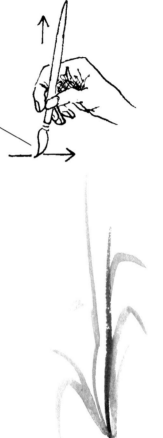

To make leaves that look loose and natural, hold your brush so *the top of the handle points away from you* — the hairs will be pointing towards you and the brush will be horizontal with the table and paper.

Then, with the brush loaded with green, slowly bring it down to touch the paper. Keep moving the brush away from you until all the hairs are touching the paper, and then — like an airplane — slowly lift up and take off from the paper.

To make leaves that bend, twist your wrist and brush to the right or left after touching down.

The Wild Rose

Now let's try our brush strokes and paint a wildflower.

COLOURS: Rose Madder Genuine, Alizarin Crimson, New Gamboge, French Ultramarine

BRUSHES: #6 or #8 round, #2 rigger

Step 1 • Sketch and initial wash

With an H pencil, lightly sketch the subject.

FLOWER:

Mix one puddle of very light Alizarin Crimson (more water, less paint) and a second, stronger puddle of Rose Madder Genuine.

Wet the flower petals with clean water.

While the petals are still wet, drop in the Rose Madder Genuine and Alizarin Crimson. You want a variety of pink colour within the petals, so tilt the paper and let the colours flow around the petals. With a clean, damp brush, you can pull some colour gently to the edges of the petals and/or lift colour.

While the flower is still wet, drop New Gamboge into the middle of the flower.

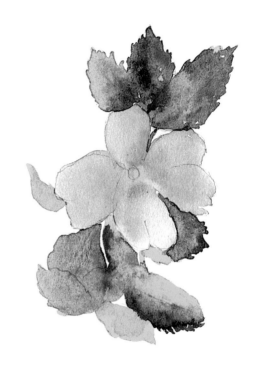

Let the flower dry.

LEAVES:

Mix a puddle of New Gamboge and a separate puddle of French Ultramarine. Let the edge of the puddles mix the colours together to create a yellow-green colour.

Apply a wash (wet on dry) of the yellow-green to the individual leaves, varying the colour by dropping in New Gamboge in some areas and French Ultramarine in others.

Let the leaves dry.

Step 2 • Glaze

Using darker versions of the pink and green, glaze over the initial wash to begin to shape the rose and the leaves. For example, where petals overlap there is a darker, cooler pink on the bottom petal, whereas those parts of the petals directly exposed to sunlight are much lighter in value and slightly warmer in temperature.

Darken the puddle of Rose Madder Genuine that you mixed for *Step 1* by adding more paint.

Float colour in by wetting one petal at a time and dropping Rose Madder Genuine in the middle part of the petal. Tilt the paper to make the colour flow to where you want it on the petal. When the paint is where you want it, lay the paper flat and let it dry. Repeat for all the petals.

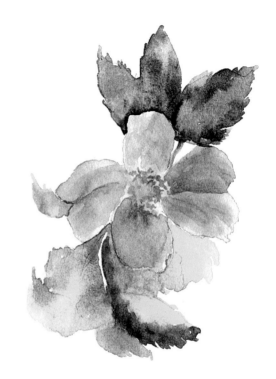

Using darker shades of the leaf colours, repeat the above procedure for the leaves. On one or two leaves, bleed in a little Rose Madder Genuine also.

Step 3 • Details

FLOWERS:

Using more paint than water, mix two small puddles for darks in the centre of the rose — one New Gamboge, the other Burnt Sienna.

Using the tip of your rigger brush, add New Gamboge and then Burnt Sienna to darken the centre of the flower, for the pistils and stamens.

Mix Alizarin Crimson with Rose Madder Genuine and add a touch of French Ultramarine for the cast shadows on the petals.

Using a round brush, create (wet on dry) the shadow areas, one petal at a time, by pulling the colour from the outside towards the centre. At this stage, it would be easy to spoil the painting by doing too much. Before putting brush to paper, take a good look at your subject to clearly determine the location of the darker Rose colours on the petals.

LEAVES:

Mix a puddle of darker-value green using French Ultramarine and New Gamboge. At one edge of the puddle, add a little more water for a lighter value of the same colour.

Using a round brush, negative paint the leaf veins, varying the value of the colour — darker in the shaded areas and lighter in the direct light. (Negative painting the veins is painting the spaces between the veins, leaving the veins the original colour.) If you have a difficult time seeing the negative space, use a pencil to draw the veins, then paint the large spaces behind the veins.

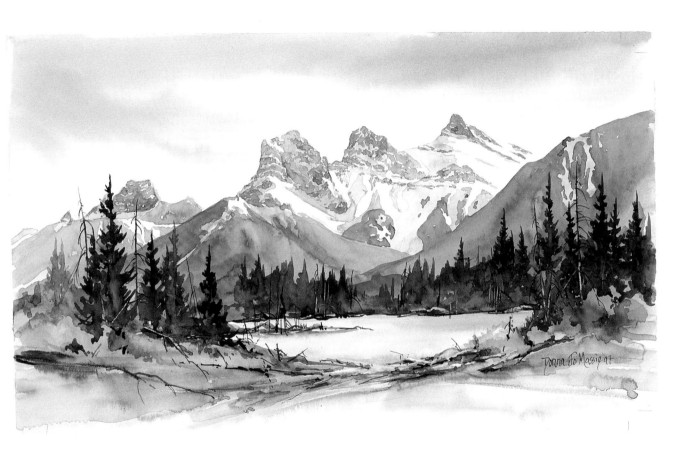

The Three Sisters, near the town of Canmore, located 90 kilometres from Calgary.
From the town centre, trails easily lead to views like this.

Our First Picture

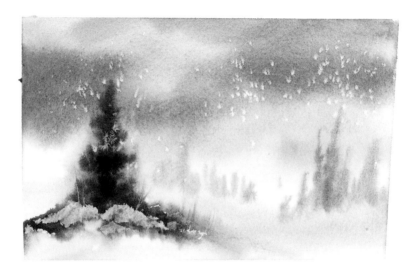

Mountain Snowfall

Location: Policeman Creek, Canmore. A trail begins at the historic North West Mounted Police Barracks on Main Street and winds through town for approximately 2 kilometres, with views similar to this picture. Watch for the ducks!

Colours: French Ultramarine, Burnt Sienna, Alizarin Crimson, New Gamboge, Winsor Green (Blue), Cerulean Blue

Brushes: 3/4-inch flat, #6 or #8 round, #0 or #1 rigger. **Also**: old credit card, table salt.

Use a wet-wet painting technique: the paint will go on wet paper to create a soft picture.

Step 1 • *Preparing your paper*

Tape your paper on all four sides to Plexiglas or a board.

With one finger, push the tape down all along the inside edge. This will prevent water from creeping under the tape and causing a backrun where you don't want it.

Sketch the main lines of the picture on your paper. Sketch *lightly* with your H pencil. It should look like the sketch on the right.

Remember, start with the longest line — the background trees.

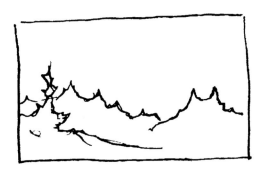

Step 2 • *Preparing your paint*

Next, let's make puddles of all the colours you will need for this painting. Once the paper is wet, you have to be ready to paint!

Also, have two to three pinches of table salt ready in a container or on a napkin.

Mix the following colours by dipping your brush in the colour and bringing it to the middle of your palette. Add only water from the tip of your brush to dampen the colours. Mix colours by placing them close to each other in the middle of your palette and blending the edges together.

SKY: French Ultra and Burnt Sienna (and a touch of Alizarin Crimson).

ROCKS: Thick French Ultra and Burnt Sienna.

TREES: French Ultra, Burnt Sienna and a bit of New Gamboge and Cerulean Blue.

DISTANT TREES: Add more French Ultra to the Burnt Sienna and New Gamboge.

Step 3 • Dampening paper, sky, foreground and distant trees

Wet the paper using your flat brush dipped in clean water. Because watercolour paper has a coating (called sizing — a binder added to the paper during manufacturing), you have to go back and forth over the paper three to four times with your wet brush to let the water soak in evenly. *Go over* the masking tape. There shouldn't be any puddles of water — wipe any excess water at the edge of the tape with a tissue. If you look at the paper, it should be *shiny* wet. Tilt the paper in the light and see that it has a shine on it. If you then count slowly to fifteen before putting sky colour on the paper, the paper will be at the proper dampness so the sky will not disappear.

Now we'll paint. Don't stop to admire the scenery or talk to a friend. *The paper is drying even as you are reading this!*

"A painting must be a love affair — you cannot paint half-heartedly."
— Ed Whitney

SKY: *Load* your flat brush — lay it sideways in your puddle of sky colour. This way, it will hold a lot of the colour in its belly instead of only on the tip. (Don't just tickle the colour with the point of the brush!)

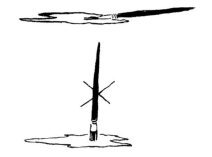

Don't be afraid of all that white paper; take your flat brush and go from the tape across the top edge of the wet paper and watch your sky appear!

Add more paint to your brush and make another brush stroke below the first one. Leave some white areas for variety and move the brush so that the wide part, not just the edge, touches the paper.

ANOTHER TIP: Go from outside tape edge to outside tape edge; don't stop at the edge, or the paper will dry unevenly.

BIG TIP: Tilt the board and watch the fingers of clouds appear. Lay the board flat to stop movement. Immediately begin painting the foreground and distant trees.

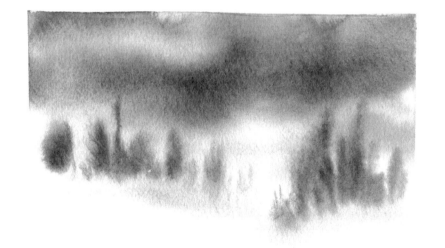

Step 3: Sky, foreground and distant trees.

FOREGROUND: Take the brush, add a bit of French Ultra blue and use this colour to make brush strokes across the bottom half of the paper. This will make snow shadows. Using the same colours for the snow will make it reflect the sky colour just as it would do naturally. *Keep painting.*

DISTANT TREES: Take your round brush and dip it in water to dampen and pick up the tree colour. You might want to add a bit of French Ultra, as this will create a feeling of depth. With the round brush loaded with paint, push the brush tip down and pull to the bottom of the trees.* With each *push* and *pull* of the brush, lift it straight up off the paper when you reach the bottom of the tree.

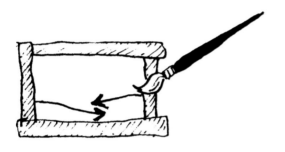

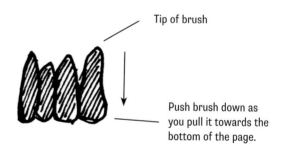

Tip of brush

Push brush down as you pull it towards the bottom of the page.

* Tip: If you are getting "palm trees" that fuzz at the top, pull down faster or wait until the paper is drier so the paint won't spread as quickly.

Place the brush strokes next to each other and they will blend together.

Move your brush gently across the bottom to fill in spaces and make the trees grow together. Remember The Three Bears and vary the heights of the trees.

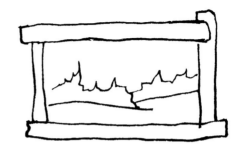

A BIG TREE: Dip into your paint for tree colour and make a big tree on the left-hand side of the paper. Paint a straight line for the trunk, then add branches getting gradually wider at the bottom. Make the tree darker and larger than the background trees. This creates perspective, or a sense of distance, on your flat surface. (Things in the foreground are larger and more detailed; things in the distance are smaller and bluer and have less detail.) If your colours are too light, use more paint.

"Whatever you think or feel, your exact state at the exact moment of your brush touching the canvas is in some way registered in that stroke."

— Robert Henri

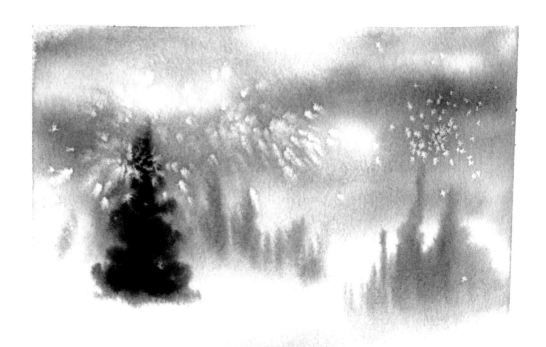

Step 4 • A few grains of salt

Now, the exciting part. *Before* the paper dries, sprinkle a few grains of salt across the sky and trees. *Few* is the operative word here. Too many, and you will get a blizzard. This is one of those instances when more is *not* better. Stand back and watch the snowflakes appear. This will take a few minutes. (If you don't get snow, you know your paper was too dry. If you get big blobs of snow, you know your paper was too wet.)

Step 5 • Rocks

By now your paper will be almost dry.

Wash out your brush. Touch it on the tissue to get all the water out, then dip your brush into the *rock* colour; the paint should be thick and dark. Use some pure French Ultramarine and Burnt Sienna and let the colours mingle at the edges.

Brush the rock colour on the paper under the trees and bring it out to the side, keeping the tops of the rocks angular.

As soon as you have the paint on the paper, take the credit card and, holding it with your thumb on one side and fingers on the other side, *press* the flat edge in the paint and *push* up, then at an angle *down* to create highlights on the rock.

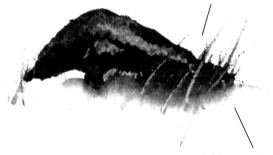

To make grass, scrape the tip of the credit card in the wet paint!

You might want to add a few branches or twigs by using a rigger.

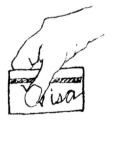

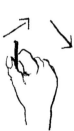

See the Shadows

Shadows make objects three-dimensional. That is why you see artists painting and photographing in the morning and evening when shadows are distinct. You can paint the mountains by using only the shadows — let's try it. This will help you see the shadows when you look at mountains.

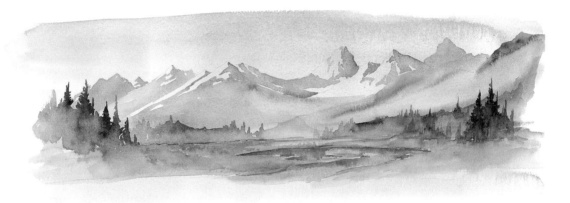

Commonwealth Peak, Kananaskis Country. From Canmore, take the Smith-Dorrien Spray Trail 40 kilometres to the Mount Shark turnoff. On your left you will see Smuts Creek and Commonwealth Peak.

Colours: French Ultramarine, Alizarin Crimson, Burnt Sienna, New Gamboge, Raw Sienna

Brushes: 3/4-inch flat, #6 or #8 round

Step 1 • Sketch

Sketch the illustrated outline on your watercolour paper. Use an H or HB pencil and *lightly* draw on the paper.

Step 2 • Sky

Mix a big puddle of French Ultramarine. Add a *touch — only a touch —* of Alizarin Crimson* to warm it slightly. We are going to paint the sky in one graded wash of colour and we must have a mid to light value. If the sky is too dark, you won't be able to see the mountains and foreground since they each have to be darker. Once you have your big puddle, *make a value scale* on a scrap piece of watercolour paper; the lightest puddle should be Value #1. *To make a colour darker, add more paint.* Load your flat, 3/4-inch brush with colour by pressing the belly in the puddle of paint (as you saw on page 30).

Now, with the sky tilted slightly upward, start at the top and move the brush from one side to the other, letting the colour flow off the flat, wide side of the brush. You should have a bead of colour collecting at the bottom of this first brush stroke. *Keep moving the brush*, overlapping each previous brush stroke. When you move down the paper to about halfway, dip your brush in clean water to make a graded wash and continue to the bottom. *Do not stop — no* coffee breaks here! *Bravo!* That's Step 1 completed. *Let it dry before going on to the next step.*

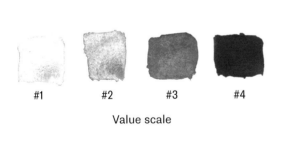

#1 #2 #3 #4

Value scale

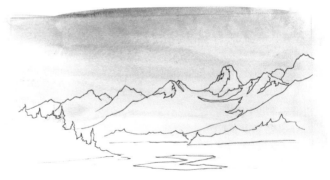

*Remember: Alizarin Crimson is the Howard Stern of paints! It has a strong personality – a little dab'll do ya.

Step 3 • *Mountains*

Next, we want to make the mountains appear by painting in the same blue colour, but this time using a mid-value (#2 on your value scale). If necessary, you can sketch *lightly*, with your pencil, the outline of the mountain over the graded wash. If you want to show light hitting the left-hand side of the slopes, you can paint around the shapes you see in Step 2, or you can simply paint the mountain range as one shape. This can be very effective and a good way to begin!

Load your flat brush with colour (the colour should flow off the brush with a bead of colour collecting along the edge) and begin painting the mountain range — from left to right, top to bottom. Make sure you have a lot of paint on your brush; after each trip across the paper, reload your brush.

When you get halfway to the bottom of the page, add more clean water. This will give you a *graded wash* of colour. Let it dry before going on to the next step.

Overlap each brush stroke as you paint to the bottom of the paper. Use the flat brush, with the wide edge vertical to the mountain.

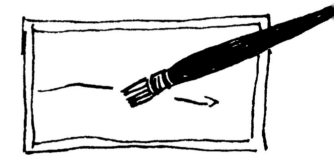

Step 4 • Background, mid-ground and foreground trees

Mix your blue puddle of colour with a touch of Alizarin Crimson to create purple. Take Burnt Sienna and New Gamboge to the centre mixing area. We want these colours to mix and mingle* on the paper to create exciting colours.

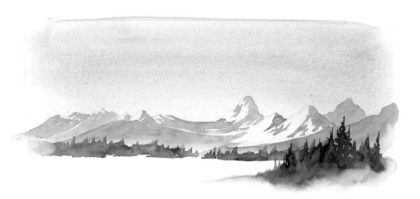

BACKGROUND TREES

Dip your flat brush into the French Ultramarine and make the entire shape of trees for the background. Add a touch of Burnt Sienna at the bottom of the tree shape. Soften the left and right edges of this shape to prevent a hard edge where the foreground trees will overlap this shape. Let it dry.

* Think of M&Ms to help you remember to MIX and MINGLE your colours

FOREGROUND TREES

Look at the shape for the foreground trees. Fill this shape with blue colour just as you did for the background trees; before it dries, add your jewels of colour (at the bottom edge) — Burnt Sienna and New Gamboge. Soften the bottom edge where it will blend into the grass. Remember: let the colours mix and mingle inside the shape. You can fiddle around at the top of this shape and add some treetops with the point of your round brush. *The edge will tell you what this shape is.* The foreground trees on the left can now be added; use less water to make your colour stronger since these are the closest trees. Pull a few treetops up here. Let it dry!

Step 5 • Add the meadow and the stream

Mix a puddle of Raw Sienna, a puddle of French Ultramarine and New Gamboge for green, and a puddle of Burnt Sienna with a touch of French Ultramarine.

Load your flat brush with French Ultramarine and New Gamboge and, starting at the bottom of the distant trees, paint the meadow by moving the brush horizontally across the paper. As soon as the brush needs more paint, change the colour you pick up and *bump* it along the edge of the colour just applied.

Move quickly across and down the page, *skipping* over the stream as you go. Make a decision quickly if you think the colours are too stripy or not brilliant enough; you can add colour or blend — with a clean, damp brush while the paper is still wet. Let it dry.

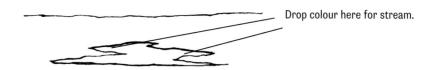

Drop colour here for stream.

*"Life is very interesting —
if you make enough mistakes."*

— Georges Carpentier

Once the meadow is dry, load your round brush with clean water and wet the stream area until it is *shiny wet*. (Tilt the paper so you can see the light shining on it.) Drop the French Ultramarine from the top edge of the stream, then tilt the top of the paper upward so the colour flows down — *instant stream!* *Congratulations on completing your watercolour sketch of Commonwealth Peak!*

Rock On: Look at those Peaks and Valleys

The Rocky Mountains started as layers of mud deposited like sheets of paper on the ocean floor. The action of global plates colliding caused folding and faulting of these layers.

With the passage of time, continued pressure — and more folding and faulting — raised the foothills and mountains.

Over the course of millions of years, erosion started carving the peaks. Then glaciers came along and began sculpting the shapes of today's mountain peaks and valleys.

If you look — really look — at a mountain, you can see the layers. Sometimes they are angled up sharply; sometimes you can follow a layer from peak to peak, across air, like the layers in the mountains at Moraine Lake.

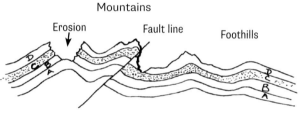

We must paint what we SEE — not what we think we see. The mountains are not one brown or grey colour. They can have pinks and greens, orange, and different hues of purple. Look at the rocks of O'Hara's trails in the painting of Ringrose Peak to the right, or at the orange band of sandstone in the Kananaskis Range!

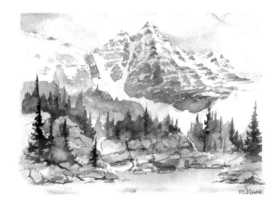

A Monochromatic Painting: Using One Colour

Step 1

Sketch Mount Assiniboine on watercolour paper.

Step 2

Mix a mid-value puddle of Sepia. With your flat brush, wet only the sky area using the edge of the brush to make a sharp edge along the mountaintop. Dip into the Sepia puddle and add colour to the sky, brushing from side to side; leave some white areas. Let it dry.

Step 3

Using the same puddle, add the shadows on the mountain and the midground, painting colour on dry paper, working around the white snow areas. When you get to the foreground, wet the area, load your brush and add colour by moving the brush from the side to the bottom of the paper, creating an angle for the hillside. Let it dry before moving on to Step 4.

Step 4

Add more Sepia to your puddle and, using the round brush, paint the rock in the mountain. Paint the midground trees, using the same colour and being careful to leave white areas for snow.

Step 5

Paint the foreground tree shapes in the darkest Sepia value. Use a rigger to paint the bare trees, branches and twigs.

Mount Assiniboine, located 27 kilometres from Sunshine Village and 17 kilometres from Spray Reservoir

Colour: Sepia

Brushes: #8 or #6 round, 3/4-inch flat, #0 or #1 rigger

How to Make Mountain Colours

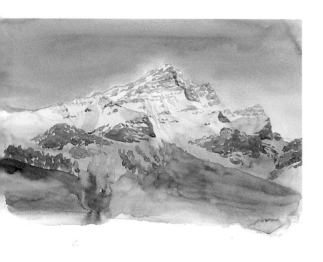

SKY: Cobalt Blue and French Ultramarine with a touch of Rose Madder Genuine

WARM COLOUR ON SUNLIT PEAK: Wet the mountain and drop in Aureolin Yellow and Rose Madder Genuine.

SHADOWS: French Ultramarine and Cobalt Blue

LIGHT ROCK: Burnt Umber, Rose Madder Genuine and Transparent Yellow

DARK ROCK: French Ultramarine, Burnt Umber and Rose Madder Genuine

TREES: French Ultramarine and Burnt Umber

"Colour is one of the great things in the world that makes life worth living to me..." — Georgia O'Keeffe

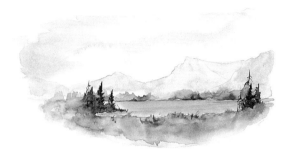

ALPINE LAKE BLUE

COLOURS: Winsor Blue (red shade) and Winsor Green (blue shade)

Mix colours together, wet the entire lake area and drop in colour at the far shoreline. Tilt your paper and let the colour flow downward.

TREES: SPRUCE, FIR, PINE

COLOURS: Winsor Green (blue shade), Alizarin Crimson, Burnt Sienna; or French Ultramarine and New Gamboge; or Winsor Blue (red shade) and Burnt Umber

These different mixtures of colours will give you a variety of mountain tree greens.

COLOURS: New Gamboge, Cadmium Orange, Burnt Sienna

While the initial wash of New Gamboge is wet, blend in the other two colours one at a time. The tree trunk is a mixture of French Ultramarine and Burnt Sienna.

ROCKS

COLOURS: Burnt Umber, French Ultramarine

Lay the paint on thick, and scrape it with a credit card or palette knife for highlights.

COLOURS: New Gamboge, Raw Sienna, Light Red, Alizarin Crimson, Winsor Green, Burnt Sienna, Burnt Umber

Wet the bush areas. Drop in the yellows and reds. Let the colours *mix and mingle* on the paper. When the area is dry, add depth by using a darker value to create the top of the bushes and lose the edge by pulling colour up with a clean, damp brush. Mix Winsor Green, Alizarin Crimson and a bit of Burnt Sienna for a rich, dark tree green. The bottoms of the trees should have a rounded bush shape; you are painting negative space (*behind* the bushes to make the bushes jump out).

"Every child is an artist. The problem is how to remain an artist once one grows up."

— Pablo Picasso

Getting to Know Your Colours

Testing your colours for
transparents or opaques

Take a piece of your watercolour paper. Paint a one-inch strip of India ink down the middle. Let it dry overnight.

Paint each of your watercolours over the strip of India ink so that they overlap on each side. Get the colour thick on your brush and only paint over the strip once. You will see some colours sit on top of the India ink; they are opaque. Other colours disappear; these are transparent.

This will help you when mixing colours and painting: use your transparent colours first, and your opaques last as they will cover the transparents.

Use a #6–#8 round brush, and clean the brush after each stroke. Use full, rich paint and don't go back over the stroke after it's painted.

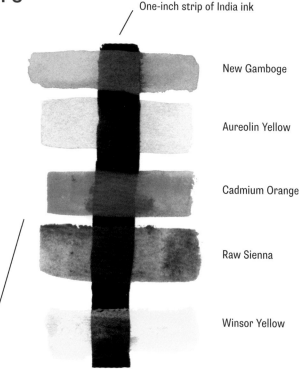

One-inch strip of India ink

New Gamboge

Aureolin Yellow

Cadmium Orange

Raw Sienna

Winsor Yellow

Testing for staining and non-staining colours

On a piece of watercolour paper, paint a rectangle of each of your colours. Make the colours thick and at least 3/4 inch wide. Let them dry overnight. Label each colour.

Take a clean, damp flat brush and scrub one half of each colour rectangle. Blot it with a clean tissue.

Colours that lift are non-staining; colours that won't lift are staining.

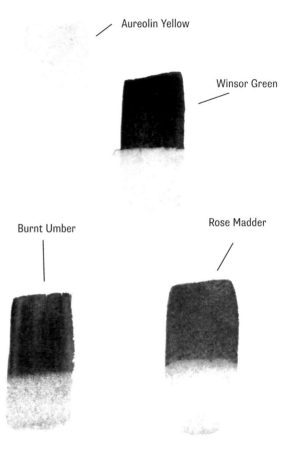

Aureolin Yellow

Winsor Green

Burnt Umber

Rose Madder

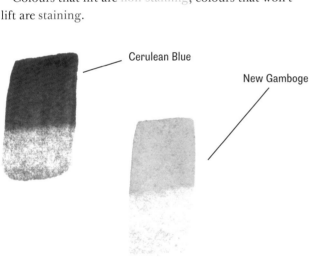

Cerulean Blue

New Gamboge

Greys: The In-Between Colours

Greys can be created by mixing many different colours, then diluting them with water. You can create warm or cool greys.

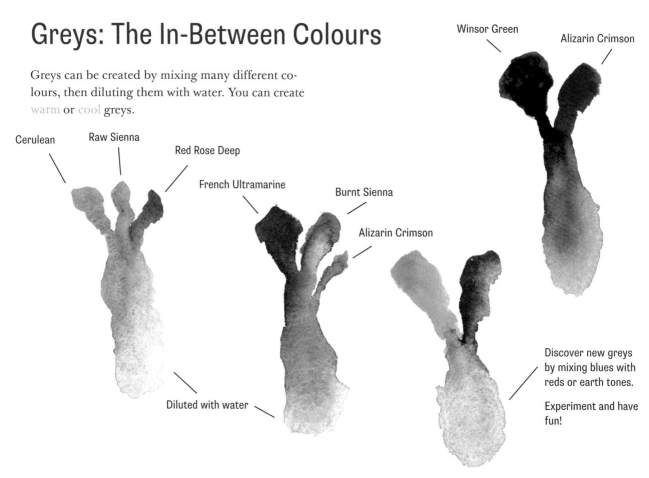

Cerulean

Raw Sienna

Red Rose Deep

French Ultramarine

Burnt Sienna

Alizarin Crimson

Winsor Green

Alizarin Crimson

Diluted with water

Discover new greys by mixing blues with reds or earth tones.

Experiment and have fun!

Greens Are Great!

But you need *variety*. Learn how to make many different greens.

A GRAINY GREEN

French Ultramarine +
New Gamboge +
Burnt Sienna

**WALTER PHILLIPS'S
FAVOURITE GREEN**

Winsor Green +
a little Alizarin Crimson +
Burnt Sienna

**A LIGHTER
GREEN**

Raw Sienna +
Cerulean Blue

STAINING GREENS

Prussian or Antwerp Blue +
New Gamboge +
Burnt Sienna

**AN OLIVE
GREEN**

Winsor Blue +
Cadmium Orange

Painting the Mountain Landscape: It's a Puzzle

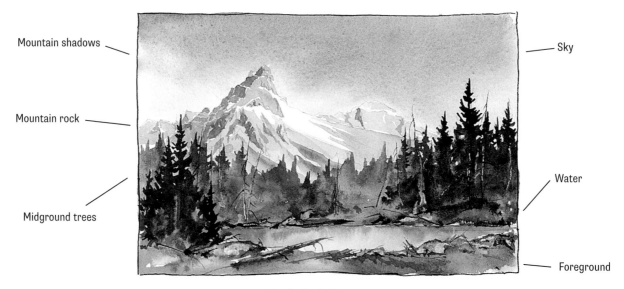

Mountain shadows

Sky

Mountain rock

Water

Midground trees

Foreground

Cathedral Mountain
Location: Lake O'Hara. Walk to the Alpine Club hut.
Look across the bridge in front of the hut to see Cathedral Mountain.

Colours: French Ultramarine, Raw Sienna, Burnt Umber, New Gamboge, Alizarin Crimson, Paynes Grey, Winsor Green (blue shade), Winsor Blue (red shade)

Brushes: #6 or #8 round, one-inch or 3/4-inch flat, #2 rigger

Step 1 • Sketch and sky

Lightly sketch the big shapes (see example) with an H pencil on your paper.

Mix a big puddle of French Ultramarine. Test the colour on a scrap of watercolour paper. Adjust the colour now if you want it lighter or darker, keeping in mind that watercolours dry lighter. Clean your brush.

Use a clean, flat brush loaded with clean water to evenly wet the entire sky area. Start at the top of the paper and go back and forth several times across the sky area, using the edge of the brush to go carefully along the edge of the mountain.

Tilt the paper in the light until you can see the shiny, wet surface. Fill in any dry areas you may have missed. Brush the water *over* the masking tape to ensure that the edges of the paper are wet. Mop up any excess water along this edge with a tissue — moving carefully along the edge of the tape, not touching the paper itself.

While the sky area is shiny wet, load your flat brush with the French Ultramarine, making sure you fill the belly of the brush with paint by *pushing* and *rolling* the entire brush in the paint puddle.

Now, *paint quickly* before the paper dries. Start at the top left of the paper and, with one stroke, paint from one side to the other (back and forth), loading your brush with more colour after each side-to-side overlapping stroke. *Stop* putting colour into the sky when you get to the top of the mountain peak. Tilt your paper up so the paint runs down towards the mountain. Tilt the paper sideways, and the paint will flow in that direction. *Don't touch* the paper with your brush. If you do, it will show! When the sky looks the way you want it to, lay the paper flat and let it *dry*.

Now, *relax!* That's one of the great things about painting with watercolours — built-in relaxation time!

Step 2 • Mountain shadows

When the sky has dried, use the same puddle of French Ultramarine for the shadow shapes on the mountain. The sky colour should be reflected in the shadows of the landscape. Seeing shadow shapes is an important part of making objects look real; that is why artists try to paint in the early morning or later afternoon, when shadows are more pronounced. When the sun is directly overhead, shadows are short and objects have a flat, uniform look.

Look at the shadows in the picture on this page. You have to think of the shadows as being as real as the mountain rock. They *make* the mountain! If you haven't already done so, lightly sketch in the shadow shapes.

Load your round brush with sky colour. Test the colour on a scrap of watercolour paper. Make sure the *value* (lightness or darkness) of the colour matches or is slightly lighter than the sky. If the shadows are too dark, you won't be able to see the rock colour later.

With a loaded round brush, take a *deep breath* and *go*, painting each of the shadow shapes from top to bottom. If there is a bead of paint at the bottom of the shape, take a tissue and lightly touch *only* the bead

— sucking it up carefully. If you mistakenly dab your tissue in the area you just painted, you'll get a big white spot, having changed the water content.

Voilà! Shadows! Stand back and look. You should be able to see the mountain taking shape.

Step 3 • Rock on

Okay — once the mountain shadows are dry, you're ready to paint the mountain rock! Look at the painting on this page to see the colour of the rock *in the light*, and note that the rock takes on a different colour when it's in the shadows. (see page 52). You will be painting the rock colour over the painted shadow shapes. Painting one colour over another dried colour is a technique called *glazing*. Glazing changes both of the colours.

Look carefully at the finished demonstration painting and try to *see just the rocks*. See their *shapes and co-*

lours. When you can do this, mix the rock colour using Burnt Umber and another puddle of Burnt Umber with a *touch* of French Ultramarine.

Mix a nice big puddle of rock colour. Test the colour on a scrap of watercolour paper. Hold it next to the picture on this page. Is it darker? Lighter? The same colour? Add more water to make it lighter; more paint to make it darker; more Burnt Umber or more French Ultramarine to change the colour.

Now, load your round brush. Start at the top of the mountain peak, moving your brush across and down the mountain shape. It is important to move your brush in the direction of the rock formations. In this painting, the rocks in the light angle downward to the right. The rocks in the shadow area angle to the left — for these, use the Burnt Umber with a touch of French Ultramarine. By leaving white spaces, you can create snow slopes. When you get to the bottom of the mountain, *grade* the colour to white paper by painting with *water only*, no colour.

If you want to add trees to the lower slopes, use a light blue-green (French Ultramarine and New Gamboge) and follow the contour of the slopes. Grade the green to white paper as you did with the slopes. Let your painting dry and take the opportunity to relax between steps.

Step 4 • Colour mixing

Let's paint the midground trees on the far side of the lake. First, mix a green using Winsor Green and a small amount of Alizarin Crimson. (Note: The greens for these areas won't be our darkest greens. The darkest greens will be saved for the foreground trees.) Add some Burnt Sienna to the edge of the above mixture. Test the green and add more Winsor Green or a touch of Alizarin Crimson to make the colour greener or greyer. (Green and red are opposites on the colour wheel and will neutralize, or grey each other.)

Step 5 • Distant trees/shrubs/ shoreline

Use the darker value of the green that you mixed for the slopes and make part of the puddle even darker. Also mix separate puddles of New Gamboge, Raw Sienna, Burnt Sienna, Alizarin Crimson and French Ultramarine. Work quickly now so that the trees, shrubs and shoreline blend together.

Start the bushes, shrubs and ground at the distant shoreline with Raw Sienna, moving your brush from one side of the paper to the other. *Don't stop now —* you have to keep adding other colours and letting them blend on the paper. Add New Gamboge at the edge of the Raw Sienna, keeping the idea of bushes in mind, and have your brush make rounded shapes in some areas. Add a touch of Alizarin Crimson in one or two areas, *always* letting the paint blend on the paper. Do not cover any colour completely with another colour; a stroke or two of Burnt Sienna will add the effect of logs in the forest. For highlights, I like to add thin strokes of Paynes Grey to the shoreline and then to scrape through this damp paint to create the look of rocks, branches and tree trunks.

Don't stop and admire your painting now — keep working! Wash your brush and load it with the tree colour. Starting at the top of the trees, make the silhouette of the trees, moving from one side of the paper to the other. Vary the tree colour as you work. The trees and bushes should blend together; if your bushes have started to dry out, wet them at the top edge lightly with a clean brush. You want a softness where the trees and bushes meet. You can add a bit — a bit — of detail to the tops of some — only some, not all — of the trees. Look at the example on page 56 and your *tree page. Good work!*

"Watercolour painting is like mountaineering: there are times when you swing between elation and sheer terror."

— David Bellamy

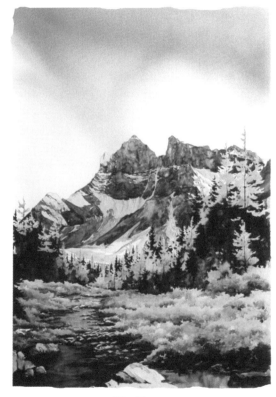

The Towers
Location: Mount Assiniboine Provincial Park, 40 kilometres from Canmore

Step 6 • Water

COLOURS: Water — Winsor Green (blue shade) and Winsor Blue (red shade)
Reflections — Burnt Sienna and Tree Colour (Step 5)

Mix a big puddle of the Winsor Blue and Winsor Green colours.

Wet the entire pond area with a clean flat brush.

Drop in the colour all along the edge of the far shoreline and tilt the paper up so the colour flows down.

If you want deeper colour, add more paint now (while it is still shiny wet). As well, using your round brush, drop in some Burnt Sienna and/or tree colour along the far shoreline and tilt the top of your paper up to give the look of reflections flowing down.

Work quickly so the colours flow and blend. *Don't go back* into the water area, especially after the shine is gone. Let it dry! If you need to make some adjustments, *wait* until the area is *totally dry* and then repeat the above process.

Step 7 • Foreground

COLOURS: Winsor Green (blue shade), Alizarin Crimson, Burnt Sienna, Paynes Grey, Raw Sienna, Light Red, New Gamboge

Mix a puddle of darkest-value tree colour: Winsor Green, a little Alizarin Crimson and Burnt Sienna. The foreground trees have to be darker than the background trees in order to appear to overlap them — giving the impression of perspective. More paint, less water.

Mix separate, intense puddles of Paynes Grey, Raw

Sienna, Light Red and New Gamboge for the shore-line foreground.

The foreground should go in with quick, confident strokes, starting with the yellows and browns. Using your flat brush, apply the colours next to each other, starting with the bush area beneath the trees and working across the paper. These colours should blend together; one colour should not totally cover another colour. Colours are like people — they need to *mix and mingle!*

Paint the trees, starting at the top. Where the trees touch the ground, the colours should blend and create the look of bushes. To do this, touch your clean brush loaded with one of the yellows to the bottom of the tree area.

You might even want to create an intentional back run here by simply touching the bottom of the tree area with a drop of clean water, creating a "flower" that looks like a bush.

Now for the final touches. Using hints of Paynes Grey and your Rigger brush, add a log shape and

branches overlapping the water. You might also want to scrape in some rocks.

It's time to stand back and look at the whole picture. A mat helps you focus and see the finished piece more clearly. If you have a mat, place it over the picture, or make a mat from strips of scrap paper taped together.

Congratulations! The pieces of the puzzle are now a mountain landscape! And, you know what — every time you paint you will learn more and become a better painter!

Inspiration: Take a Page from My Sketchbook

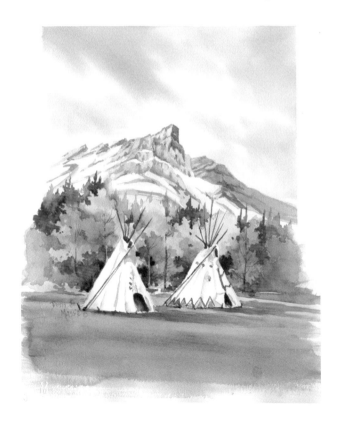

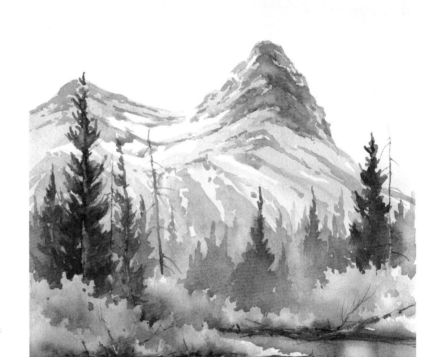

Opposite left: **Banff Indian Days**,
Banff National Park, 12 x 9 inches

Opposite right: **Mountain Light**,
7 x 5 inches

Right: **Ha Link Peak**, Canmore,
Alberta, 8.5 x 9 inches

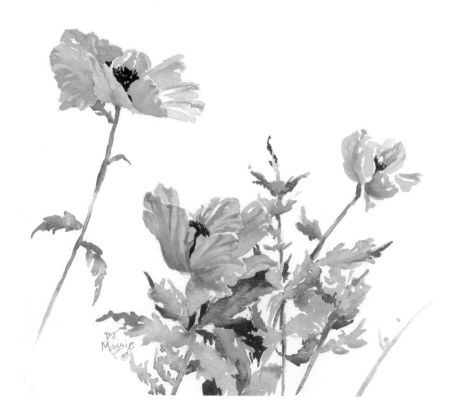

Left: ***Poppies***,
10 x 11 inches

Right: ***Shadow Lake
and Mt. Ball***,
8 x 12 inches

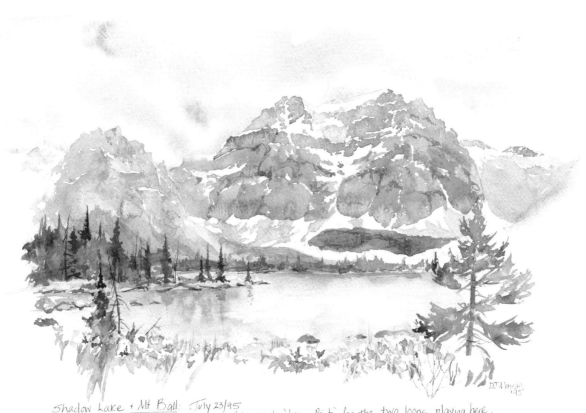

Shadow Lake & Mt Ball: July 23/95
I named this point "Loon Point" for the two loons playing here.
Cloudy with the sun playing hide & seek — Mosquitos were ferocious so we had
lunch on the bridge. Most beautiful magenta paintbrushes.

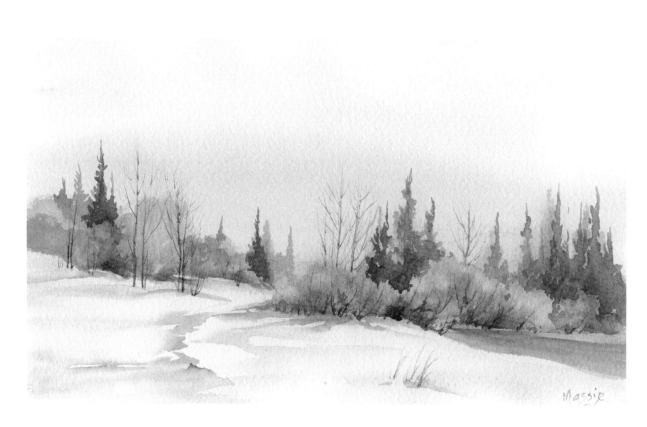

Snow Day, 9.5 x 5.5 inches

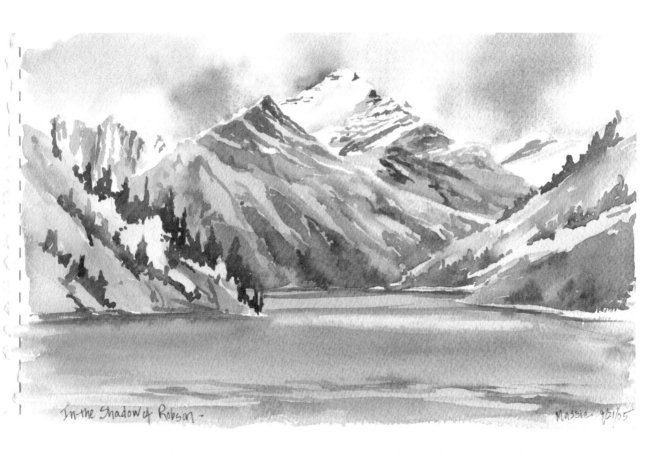

In the Shadow of Robson – Massie – 9/21/95

Kinney Lake, Mount Robson Provincial Park, Canadian Rockies, 5.5 x 9 inches

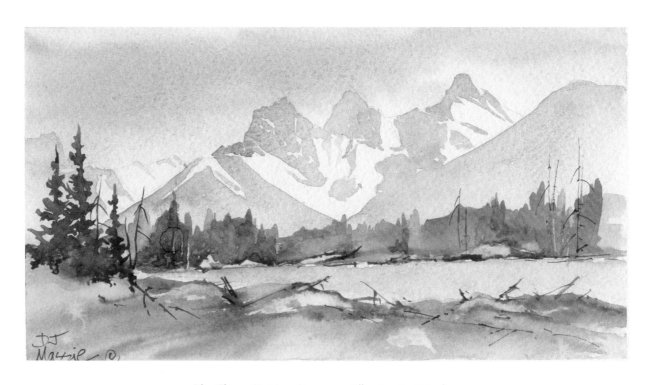

The Three Sisters, Canmore, Alberta, 4 x 8 inches

2.

The Three Sisters, Canmore, Alberta, 4.5 x 8.5 inches

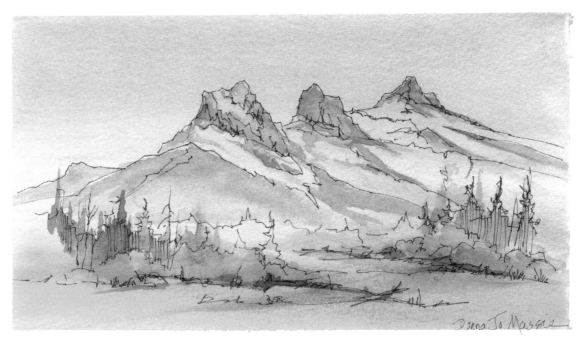

FO

Watercolour Words

BACK RUN (OR FLOWER): The effect you get when you drop clear water into saturated colour that has just lost its shine. Makes great bushes or blossoms.

BOTANICAL PAINTING: Painting studies of flowers, plants, trees and fruits from a scientific point of view.

CHIAROSCURO: The art of painting light within shadows to allow the forms of the object to show even when in intense shade. Rembrandt was one of the great masters of chiaroscuro.

COMPLEMENTARY COLOURS: On a colour wheel, directly across from each colour is its complement. Complementary colours placed next to each other create a "vibration" — the maximum contrast.

FERRULE: On a paintbrush, the metal part that surrounds and holds the hairs.

FLAT WASH: After mixing a puddle of colour, dip your brush into the colour and draw it across the top of your paper. Your paper should be tilted so the paint runs down. Add more paint as you slightly overlap each brushstroke to the bottom of the paper.

GLAZE: A colour layered over another colour, which changes the latter.

GOLDEN MEAN (OR GOLDEN SECTION): The Roman architect Vitruvius determined the ideal placement of a line or point, aesthetically, within a given space. Vitruvius found a numerical relationship, equal to 1.618, between the smaller and larger parts of a space. Simply, an area can be divided into thirds and the intersecting points are where your centre of interest should be placed.

GRADED WASH: When you draw the brush across the paper loaded with colour and, as you paint you add more clear water until you are painting with clear water at the bottom. You can't go back to the top!

MASKING FLUID (MISKIT): A latex gum used in painting to protect white areas. These areas may then be painted over. When the paint has dried, you can rub off the Miskit with masking tape or a Miskit eraser. Rub an old brush over a bar of soap, or push around in dish soap before using it with Miskit, then rinse in hot water in order to reuse the brush.

MONOCHROMATIC: A painting is monochromatic when it has been painted only in values of one colour. Burnt Umber, French Ultramarine or Sepia are all good colours for a monochromatic painting. Painting monochromatically is an excellent way to learn about value.

PERSPECTIVE: The effects of distance on the appearance of size, forms and colour. Aerial perspective represents depth by the use of colour, shading and contrast.

POSITIVE AND NEGATIVE SPACE: When you paint the object, you are painting positive space. When you paint behind the object, you are painting negative space.

PRIMARY COLOURS: Basic colours of the spectrum — red, yellow, blue. These colours can't be mixed from other colours.

SECONDARY COLOURS: Orange, green and violet can be mixed from the primary colours, so they are called secondary colours.

SKETCH: A freehand drawing, done without rulers, compasses or other instruments.

VALUE: The lightness or darkness of a colour.

WASH: Laying watercolour paint on paper.

WET-DRY: A technique in which the artist paints with wet paint on dry paper.

WET-WET: A technique in which the artist paints on paper that has been previously dampened and is still wet. The result is a diffusion of forms and colours.

Suggested Books

FOR THE BEGINNER

Albert, Greg, and Rachel Wolf. *Basic Watercolor Techniques*. Cincinnati: North Light Books, 1991.

Biggs, Bud, and Lois Marshall. *Watercolor Workbook*. Cincinnati: North Light Books, 1978.

Couch, Tony. *Watercolor: You Can Do It!* Cincinnati: North Light Books, 1987.

Harrison, Hazel. *Watercolor School*. New York: Reader's Digest Association Inc., 1993.

Johnson, Cathy. *Creating Textures in Watercolor*. Cincinnati: North Light Books, 1992.

Page, Hilary. *Watercolor Right from the Start*. New York: Watson-Guptill Publications, 1992.

Parramon, José M. *The Big Book of Watercolor Painting*. New York: Watson-Guptill Publications, 1985.

Szabo, Zoltan. *Painting Little Landscapes*. New York: Watson-Guptill Publications, 1991.

Walsh, Janet. *Watercolor Made Easy*. New York: Watson-Guptill Publications, 1994.

FOR INTERMEDIATE OR ADVANCED PAINTERS

Dobie, Jeanne. *Making Color Sing*. New York: Watson-Guptill Publications, 1986.

Hill, Tom. *The Watercolorist's Complete Guide to Color*. Cincinnati: North Light Books, 1992.

Lawrence, William B. *Painting Light and Shadow in Watercolor*. Cincinnati: North Light Books, 1994.

Ransom, Ron. *Learn Watercolor the Edgar Whitney Way*. Cincinnati: North Light Books, 1994.

Reid, Charles. *Painting What You Want to See*. New York: Watson-Guptill Publications, 1987.

Simandle, Marilyn. *Capturing Light in Watercolor*. Cincinnati: North Light Books, 1997.

Stine, Al. *Watercolor Painting Smart*. Cincinnati: North Light Books, 1990.

Wagner, Judi, and Tony Van Hasselt. *Painting with the White of Your Paper*. Cincinnati: North Light Books, 1994.

BOOKS FOR IMPROVING YOUR DRAWING SKILLS

Albert, Greg. *Drawing: You Can Do It!* Cincinnati: North Light Books, 1992.

Dodson, Bert. *Keys to Drawing*. Cincinnati: North Light Books, 1985.

Edwards, Betty. *Drawing on the Right Side of the Brain*. Boston: Houghton Mifflin Co., 1979.

Hamm, Jack. *Drawing Scenery: Landscapes and Seascapes*. New York: Perigee Books, 1972.

ART BOOKS OF INTEREST

Cameron, Julia. *The Artist's Way: A Spiritual Path to Higher Creativity*. New York: Putnam Publishing Group, 1992.

Flack, Audrey. *Art and Soul*. New York: Penguin Books, 1986.

Henri, Robert. *The Art Spirit*. New York: Harper & Row, 1923. (A classic that every artist should own.)

Ueland, Brenda. *If You Want to Write*. Saint Paul: Graywolf Press, 1987.

DONNA JO MASSIE hails from Cherokee, North Carolina, in the Great Smoky Mountains. She attended Auburn University and taught in Alabama and Florida before moving to Alberta in 1976 as Environmental Educator for Kananaskis Country. She makes frequent sketching trips into the mountains, as well as teaching popular adult watercolour classes and corporate backcountry workshops. She has been Artist in Residence at The Banff Centre and at the Columbia Icefields, and was International Peace Park Artist in Residence for Glacier National Park in the United States. Her work has been exhibited internationally and can be found in private collections around the world. Donna Jo is a member of the Alberta Society of Artists, the Society of Canadian Artists and the Elmore County (Alabama) Art Guild and is an Honorary Member of the Canmore Art Guild. She currently operates a home studio in Canmore, Alberta.

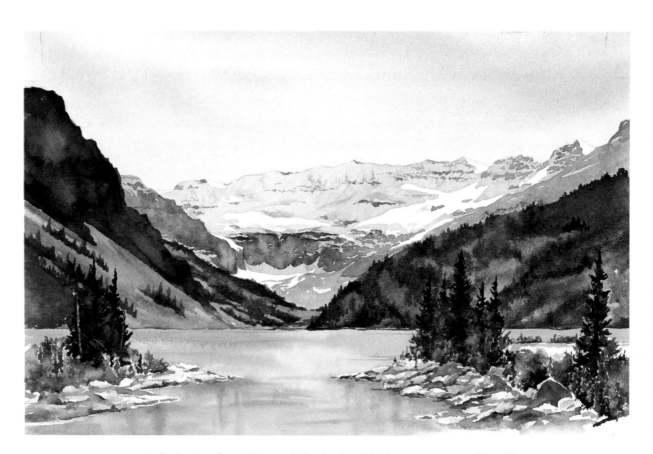

Lake Louise, from Chateau Lake Louise, 50 kilometres west of Banff